THE EAGLE JOURNAL

JOHN DUNNE

Published by:
John Dunne Photography
CENTERPORT, NEW YORK

Text and photographs copyright © 2021 John Dunne

ISBN: 978-0-578-82547-2

Cover and interior design by
The Book Couple, Boca Raton, FL

Printed in the United States of America

INTRODUCTION

Centerport, Long Island, New York, is not a spot you would think of going if you wanted to view the American Bald Eagle. However, since September 2017, it has been—at least for me. Since then, two beautiful eagles have set up home on the North Shore of Long Island and have successfully spawned seven juveniles over the past three years.

It is very exciting to see that over the past few years the bald eagle has found its way to this area, only 40 miles from New York City. Before 2006, there weren't any bald eagles here, and now it has been reported that there are at least eight adult couples.

Having the chance to view and photograph these majestic birds build their nests, fly overhead, and hunt has been a thrill.

Let eagle inspire you to use the pages of this book . . . to soar!

"Eagles soar because they always focus on their goal."

—Unknown

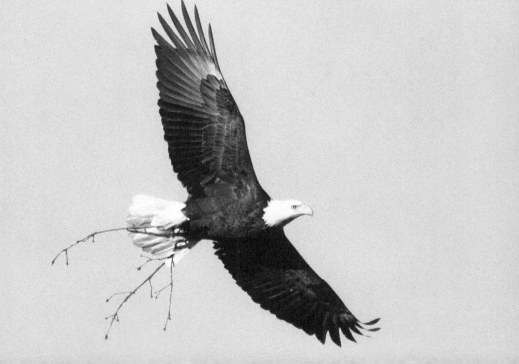

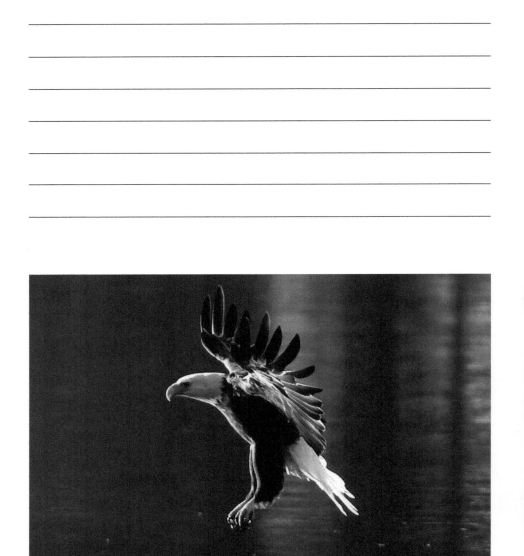

"An eagle earns its honor from the storms it endures."
—MATSHONA DHLIWAYO

"In an eagle there is all the wisdom of the world."

—Lame Deer

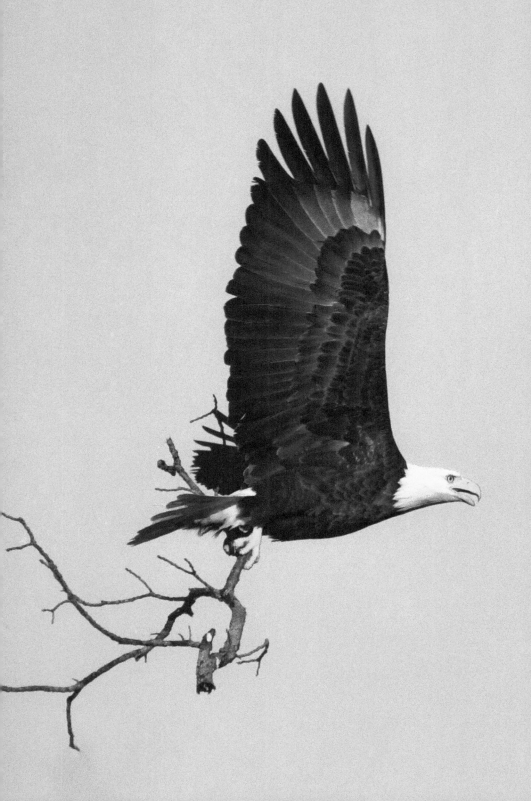

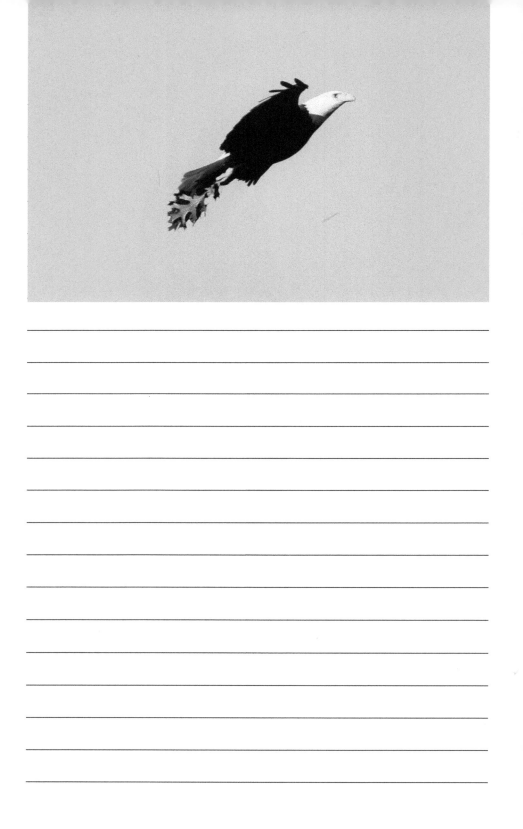

―――――――――

―――――――――

―――――――――

―――――――――

―――――――――

―――――――――

―――――――――

―――――――――

―――――――――

―――――――――

―――――――――

―――――――――

―――――――――

―――――――――

―――――――――

―――――――――

―――――――――

―――――――――

―――――――――

―――――――――

―――――――――

―――――――――

"Walk with wolves. Run with lions. Soar with eagles."
—MATSHONA DHLIWAYO

"But flies an eagle flight, bold and forth on,
leaving no track behind."

—WILLIAM SHAKESPEARE

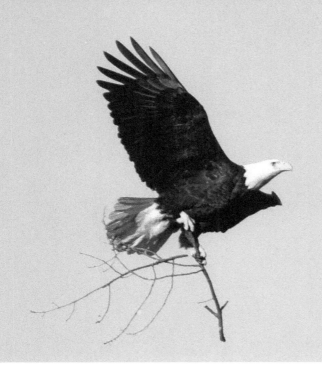

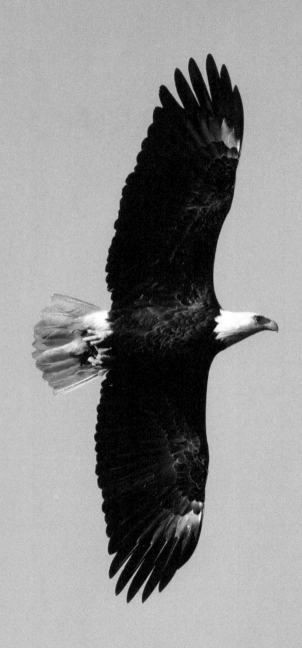

"The eagle has no fear of adversity. We need to be like the eagle and have a fearless spirit of a conqueror!"
—JOYCE MEYER

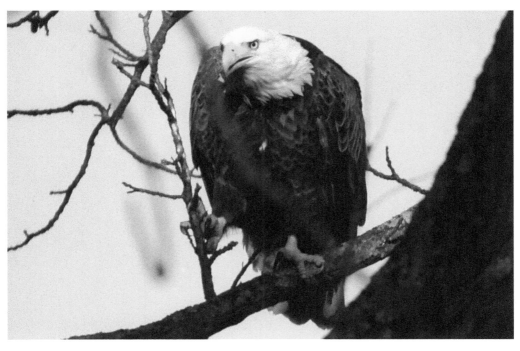

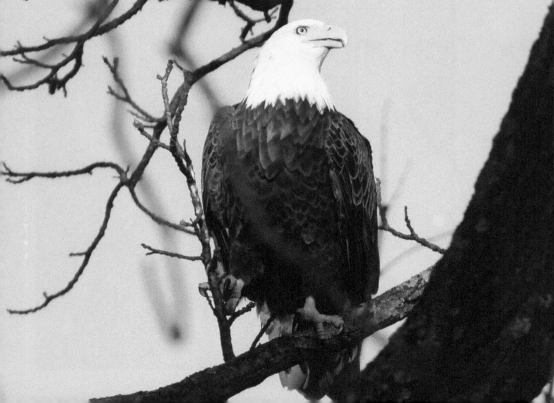

"Those who fly solo have the strongest wings."

—UNKNOWN

"The eagle has landed."

—Neil Armstrong

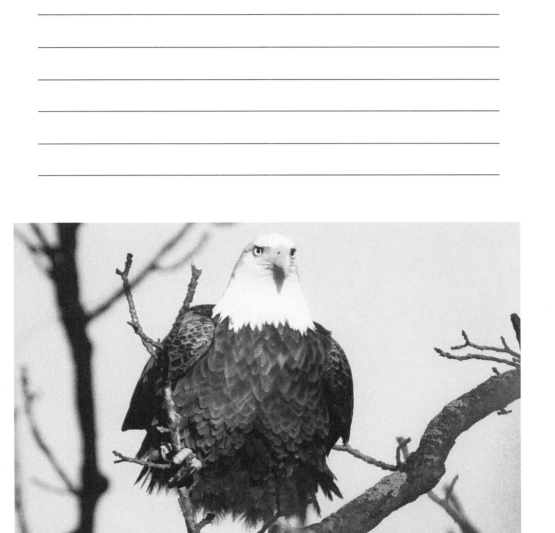

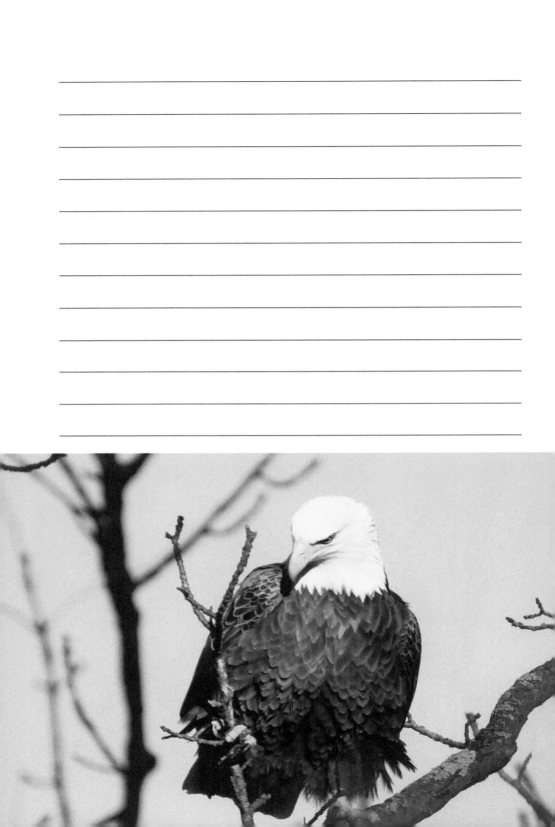

"It is better to be an eagle for one day than to be a vulture for a lifetime."

—Matshona Dhliwayo

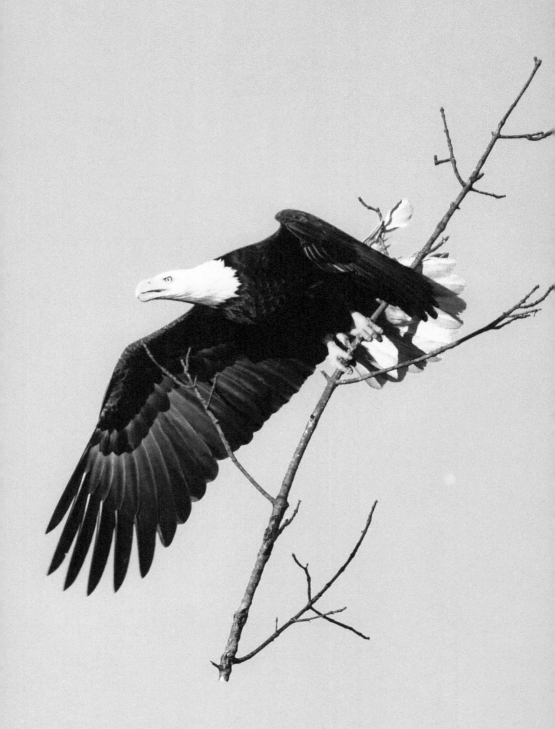

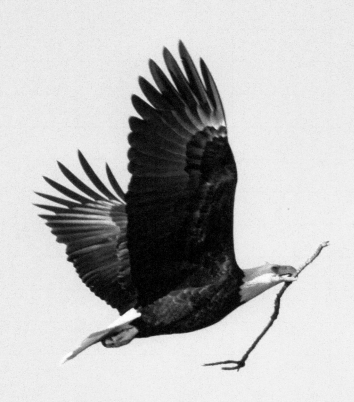

*"To soar with eagles, all you need to do
is believe that you can fly."*
—ANTHONY T. HINCKS

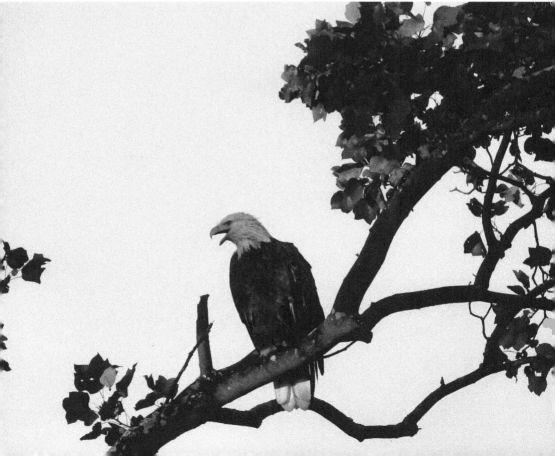

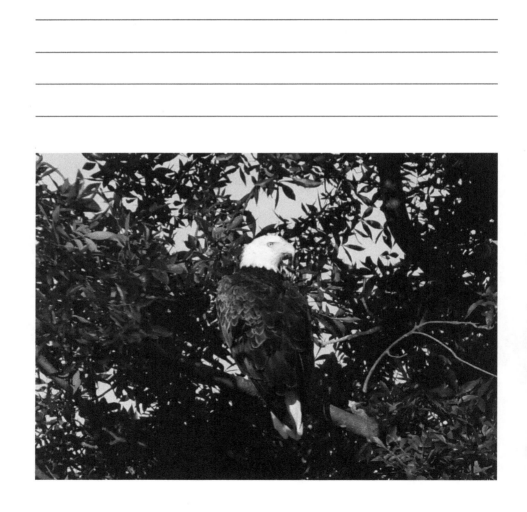

"Don't quack like a duck, soar like an eagle."

—KEN BLANCHARD

*"May you soar on eagle wings,
high above the madness of the world."*
—Jonathan Lockwood Huie

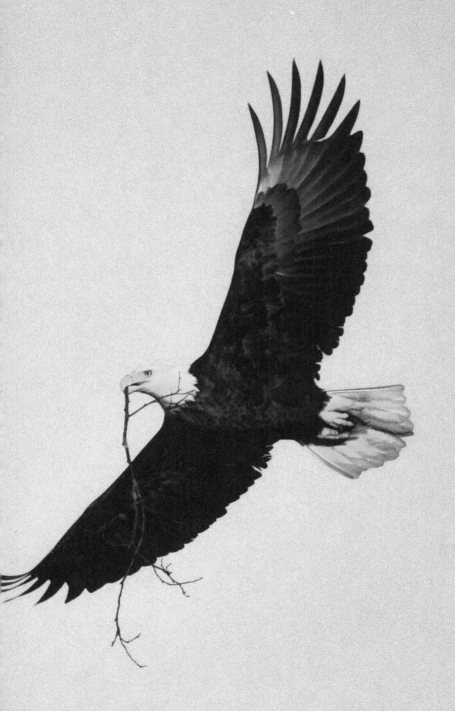

"The eagle does not escape the storm.
The eagle simply uses the
storm to lift it higher.
It spreads its mighty wings
and rises on the winds
that bring the storm."
—JACK WHITE

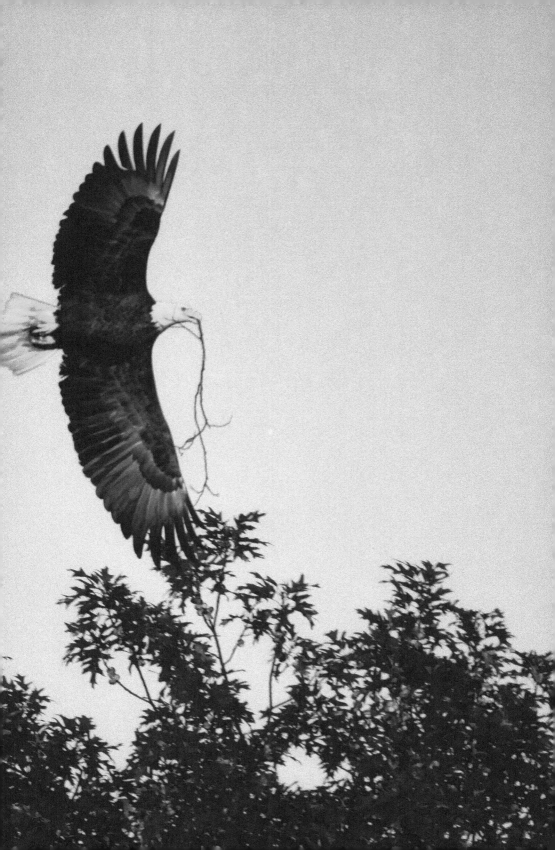

No need to teach an eagle to fly.

—GREEK PROVERB

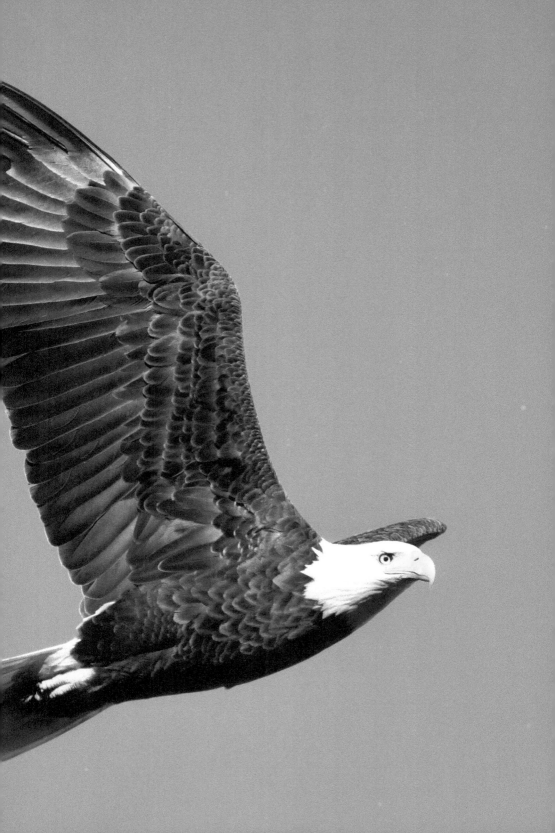

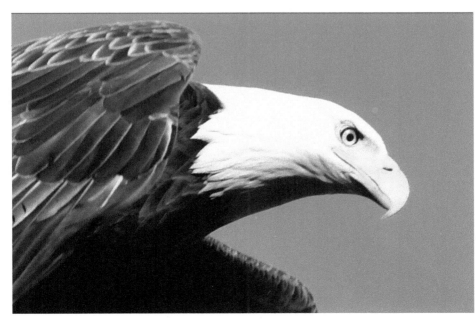

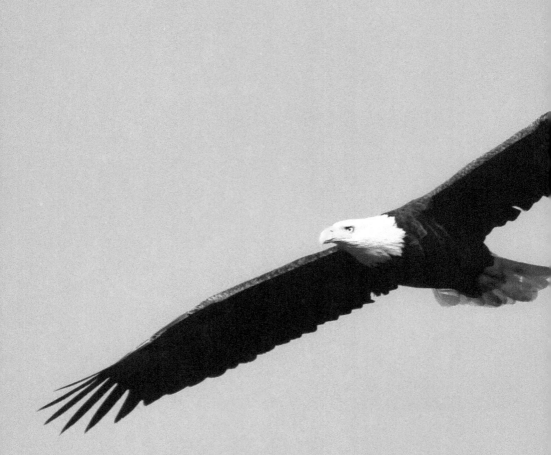

"We were free as the winds, and like the eagle,
heard no man's commands."
—CHIEF RED CLOUD

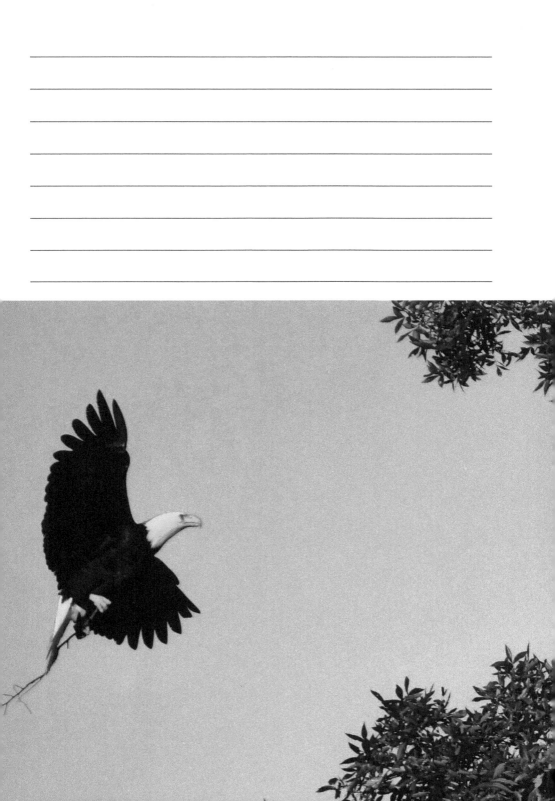

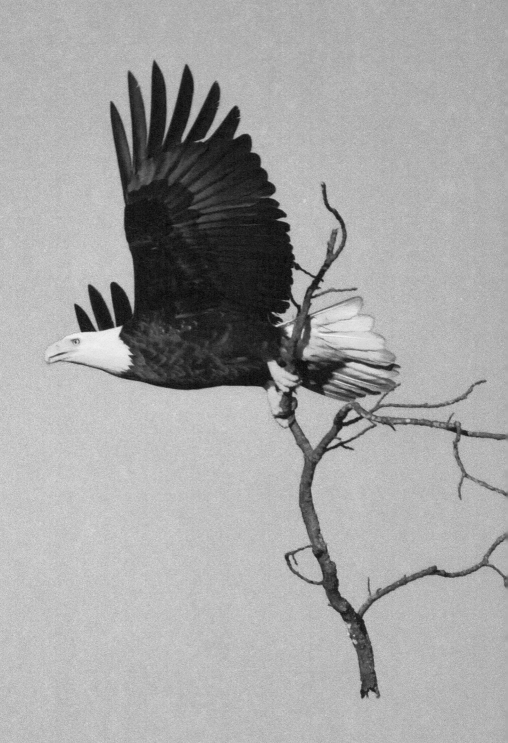

An Eagle, King of Birds, sailing on his wings aloft over a farmer's yard, saw a cat there basking in the sun, mistook it for a rabbit, stooped, seized it, and carried it up into the air, intending to prey on it. The cat turning, set her claws into the Eagle's breast; who, finding his mistake, opened his talons, and would have let her drop; but Puss, unwilling to fall so far, held faster; and the Eagle, to get rid of the inconvenience, found it necessary to set her down where he took her up.

—BENJAMIN FRANKLIN

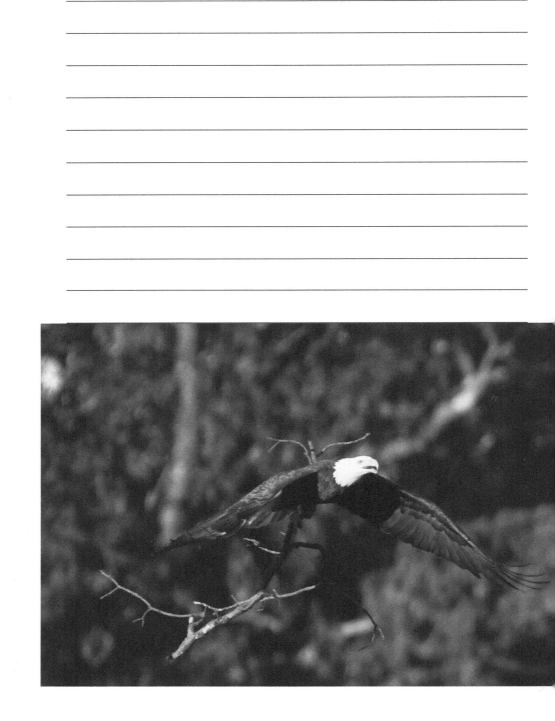

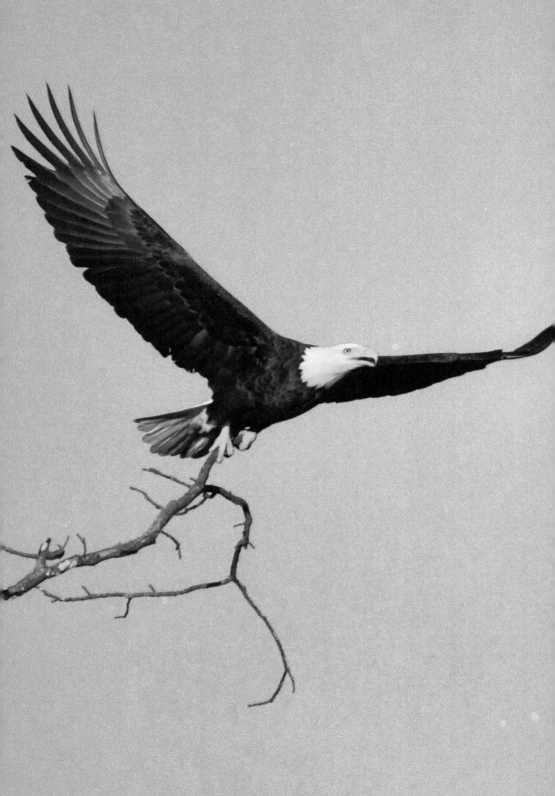

May you have the strength of eagle's wings,
and the faith and courage to fly to new heights,
and the wisdom of the universe to carry you there.

—NATIVE AMERICAN BLESSING

ABOUT THE AUTHOR

John Dunne is a nature photographer. He has a love of photographing all that is natural to this beautiful planet. From breathtaking scenery to the allure of all wildlife. Being from Long Island, NY, John doesn't normally see birds and other wildlife that one would regularly see in more rural areas. Therefore, witnessing and photographing these majestic eagles has become his passion.

CPSIA information can be obtained
at www.ICGtesting.com
Printed in the USA
LVHW072236110121
675967LV00014B/101